The Choreography
of Everyday Life

The Choreography of Everyday Life

by Annie-B Parson

VERSO

London • New York

First published by Verso 2022
© Annie-B Parson 2022

1 3 5 7 9 10 8 6 4 2

Verso
UK: 6 Meard Street, London W1F 0EG
US: 388 Atlantic Avenue, Brooklyn, NY 11217
versobooks.com

Verso is the imprint of New Left Books

ISBN-13: 978-1-83976-674-9
ISBN-13: 978-1-83976-676-3 (UK EBK)
ISBN-13: 978-1-83976-677-0 (US EBK)

British Library Cataloguing in Publication Data
A catalogue record for this book is available from the British Library

Library of Congress Cataloging-in-Publication Data

Names: Parson, Annie-B, author.
Title: The choreography of everyday life / by Annie-B Parson.
Description: First Hardback Edition. | Brooklyn, NY : Verso, 2022.
Identifiers: LCCN 2022025588 (print) | LCCN 2022025589 (ebook) | ISBN
 9781839766749 (Hardback) | ISBN 9781839766770 (eBook)
Subjects: LCSH: Choreography. | Dance—Sociological aspects. | Movement,
 Aesthetics of. | Parson, Annie-B.
Classification: LCC GV1782.5 .P37 2022 (print) | LCC GV1782.5 (ebook) |
 DDC 792.8/2—dc23/eng/20220625
LC record available at https://lccn.loc.gov/2022025588
LC ebook record available at https://lccn.loc.gov/2022025589

Typeset in Fournier MT by Hewer Text UK Ltd, Edinburgh
Printed and bound by CPI Group (UK) Ltd, Croydon CR0 4YY

To my father, David Parson, a dancer

THE CHOREOGRAPHY OF EVERYDAY LIFE

ANNIE-B PARSON

[]

Paul is lying on the couch talking to someone on the phone and he's telling them that he's reading *The Odyssey* and it reads like a blockbuster movie, and I interrupt from the kitchen to ask which movie, but he doesn't hear me because

the radio is on.

I am a choreographer by trade, and it's an unusual profession: to make and sell dances. The material, the stuff of dance, is the body, and turning that into something transactional has always struck me as contradictory, because when people first danced, it was essentially a community in physical agreement executing poeticized, ritual actions

in a circle.

But even still, it always feels very natural when I am choreographing, as organic as a leaf growing on a tree, and I specifically use this metaphor because it is the most natural thing I can think of. I have this belief, which may be more like a religion, that like plants we are fundamentally generative, and our generativity includes making things, so this leaf metaphor seems to accurately describe our liveness, plus

some metaphors are more real than the people you see walking down the street.

I didn't come up with that line, the Portuguese poet Fernando Pessoa wrote it, but when I heard it, I immediately put it on a Post-it so I would never forget it, because from the perspective of *the surface*, the exterior form, it's a formidable statement and deserves a bit of fanfare, or

a dramatic sound cue.

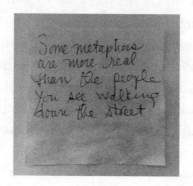

Some metaphors
are more real
than the people
you see walking
down the street

[]

Where I live there is usually someone walking their dog down the street while talking on the phone. I live in Brooklyn, where people still walk to get places they need to go and not just for exercise, and often it's tricky to walk behind

this phone/dog situation.

Because there are issues of tempo and issues of space in navigating a public area, and these are the very same issues of the body in time and space that are elements in choreography. But the difference is that in dance-making, these issues of time and space are compositional and aesthetic, so I have to remind myself that composition and aesthetics are irrelevant when

walking down the street.

In this case it's about an agreement among strangers, which is one of the things I appreciate about city life, how 8 million of us, without language or plan, gracefully find a group rhythm as we walk down the sidewalk together. So when a fellow pedestrian's tempo is at odds with your tempo, you're denied the tacit, musical duality that strangers have when walking and passing.

Plus there's the leash.

I mean, wasn't there a contract we all signed that we would glide in harmony like fish down the river?

[]

Paul says to the person on the phone that *The Odyssey* is almost like scripture, a kind of theology, but he adds that ultimately it doesn't have the resonance and strangeness of the Hebrew Bible. He says it's ultimately more like a kind of ethical instruction manual, a way to live, like it teaches you to welcome strangers with gifts and bathe their feet, things like that. At this point I wonder if it's Jack on the phone because this sounds like something they like to talk about. Jack is our son, and it turns out yeah, I hear Jack's deep voice respond, but I can't hear what he is saying because it's a merciless day in August and

the AC is turned on high.

I walk outside and see a young blonde man in a stretchy gray track suit walking his dog while loudly talking about his body on the phone, and then he slows down to peer into his screen,

and pauses.

And in this pause, which he and I now must share because we pedestrians share these intersections of time and space, I wonder: what would be the equivalent to this experience in Ancient Greece, and Menelaus floats through my mind. I imagine big blonde Menelaus arriving, with some fanfare, into the agora of Sparta with his entourage, his body oblivious to the other Ancient Greeks' bodies, who are going about their business of buying and selling,

without fanfare.

Then, still in our pause, I change my mind because from a spatial perspective Menelaus of the big blonde hair is not really like the blonde dog walker on the phone. The dog walker is oblivious to the space around him, but Menelaus is like a movie star as he enters the agora with big steps and large-scale gestures, highly aware of his use of space, though not at all aware of the others in their space, which for me brings up the choreographic term *kinesphere*. Menelaus has a large kinesphere, he takes up a lot of space, but the dog walker has a small kinesphere,

a bubble of tiny actions.

I bring this up later with Paul, this idea of an Ancient Greek equivalent to the blonde man on the phone. I am thinking that from a personal use of space he's actually more like Heracles than Menelaus. Yes, Paul says, you mean Heracles in the Euripides play when he is partying outside of King Admetos's palace, while meanwhile inside the palace the King is grieving the death of his wife, a death which the King himself is responsible for, but it takes the King most of the play to face what he did. Yeah, I say, the dog walker is actually a lot like Heracles, blind,

from a spatial perspective.

Choreographing dances makes you feel comfortable with an author because you literally put your body inside of their words, and because I have made dances for some of the 2,500-year-old plays by the Great Tragedians, I nurse a shred of dance authority, a fun delusion that I have a sense of what life was like in Ancient Greece. And though mine is most likely a concept of an Ancient Greece that is both flawed and hilarious, it is

dutifully embodied.

[]

But before Euripides, and before Fernando Pessoa and Homer, and even before the Bible, before, before, before—there was dance. For thousands of years people danced, everyone danced and there were so many reasons to dance; people danced to celebrate growth and change, weddings, rituals and funerals, initiations and births. There were dances for community-building, mostly danced in ring structures, in part for safety—there were dances for a good harvest, which are for sustenance—there were dances for prayer and war, peace and ecstasy. People danced for every aspect of life from the emotional to the physical to the spiritual. Dance was once fundamental and essential, and

everyone danced.

Plate 24. Krishna's Ring Dance. Jaipur, about 1800
The Maharaja of Jaipur, Jaipur Museum

And thousands of years later people began to dance to entertain one another, so there came to be a division between the watchers and the dancers; people danced in front of other people who were seated, and this trading of physical energy between the dancers and the seated people, this shared experience of giving and receiving kinetic energy became a community feedback loop, a call and response form, that was both a physical experience and a variation on a

symmetrical structure.

Symmetry and its variations mirror patterns in our bodies. We are bilateral with two legs/two arms/two eyes but to complicate matters, we have a back and a front, a top and a bottom, and we also have reverse mirrors in our bodies like hands, ears, and lungs, plus we have other formal variations like the asymmetries of our heart and our liver. And we animate and enact these anatomical symmetries in our lives: in the mutuality of social settings and in manners, reciprocity, justice, fairness,

and phone calls.

Paul is lying on the couch talking to Jack and I hear Jack mention *Bartleby the Scrivener,* and Paul says you can't compare *The Odyssey* to *Bartleby the Scrivener* because *Bartleby the Scrivener,* it's so interior. Paul says he thinks *The Odyssey* predates interiority, he thinks the version we have of *The Odyssey* was compiled from an oral tradition after the Old Testament, but before the Great Tragedians wrote their great, tragic, and psychological plays. This timeline completely confuses me, so after looking it up

I put it on a Post-it.

Going back to this "pause" moment between me and the blonde man in the track suit walking beside me on the street with the dog on the leash stretched across the sidewalk, I loop back to it because in this fragment I use five prepositions to describe what is happening in this simple pedestrian incident. Prepositions are little generative machines for making dance material because they direct you to *where* action is happening. For instance, physically imagine the preposition *beside*. *Beside* implies a proximity, that you are adjacent to something or someone, and it also implies a sense of pairing, or

a duet.

I like to work with grammar to generate material for dances, and verbs are even more valuable for making choreography than prepositions. Verbs are grammar's dancers, and while prepositions are useful for placement, they ultimately don't have the muscle, the velocity of a verb. But nothing rivals the front-facing elegance and postmodern stillness of

a noun.

I wonder if Pessoa and I are art-animists. Animism is the belief that there is a spiritual force which shapes and vivifies the material world, and in this case, the material world would be art, and poetics would be the animator. Poetic structures organize, energize, and color the content, and they also hold meaning. Poetic forms are like the beams in a house, and like a puppeteer in a bunraku play.

Those were similes.

[]

Paul's favorite character in his book is Athena, and he says that he loves her because she simply transforms as needed into something else, without fanfare, and he says he can picture her transformation from goddess to shepherd to spider to beggar—and then back again: from beggar to spider to shepherd to goddess, and this is joyful for him because Paul is an actor, and so he likes the idea that someone can successfully become someone else. For me, I like this image because it has four fantastic nouns. And I also like the image because the kinetic tone of the transformation has a light muscularity. Plus, Athena's transformation is in a *structural retrograde*, which is a choreographic form that

Trisha Brown invented.

Trisha Brown was a great choreographer and a virtuosic formal experimentalist, plus her dancers loved her. It's worth noting that these things are typically unrelated; good artists are not necessarily good people, and conversely good people are not necessarily good artists. But for some reason audiences are especially disappointed when artists behave badly, as if they still believe, like the Ancient Greeks, that

art comes from the gods.

Actually art comes from perception and craft plus a muscular imagination, all things unrelated to being a good person, and in dance it's especially unusual to be loved or good. My theory is that when you are making dance, the choreographer demands a tremendous amount from the dancers' bodies, and the dancers can become primarily vessels to animate the choreographer's artwork, which sounds cold, and it is at least partially cold, so over time dancers are often unhappy, especially when they pass

the seven-year mark.

Seven years sounds like a long time, but in dance-making it's the start of a deep artistic collaboration, and after that you are in a *groove*, and this groove is like dance heaven, it's your best period, but also after seven years the dancers can start to feel used and they want to walk out of your studio and not dance your dances, but your choreography is inside of their bodies so you are physically a part of them, and the dancers are in turn inside of your body because their bodies hold your dances. And because they've devoted themselves monogamously to the aesthetic of your choreography, they may have no place to go, so they feel trapped, and they start to act mean, so you want them to leave,

but you need them.

Trisha Brown was part of a group of choreographers who, in a storm of experimentation, took dance apart and put it back together differently. Trisha Brown surgically shredded the hierarchical majesty of the proscenium stage, like she literally exploded and reconfigured the Ancient Greek notion of the proscenium by dancing on a wall, or dancing on the roof of a building, or dancing outside of the theater while the audience was inside. And her *tone*, which in dance is a salient and overlooked component of artistry, her choreographic tone was efficient and spare, like the people buying and selling without fanfare in the town square.

Those were internal rhymes.

At the same moment in history, on more conventional stages, what was highly valued in theater was for a performer to disappear into a character, to pretend to be someone else. But why pretend when so much is actually happening? By simply doing and being, Trisha Brown rejected pretending as an excessive form of dissembling; her choreography comprised factual, unadorned movements without

the drama of pretend.

The Ancient Greeks were not pretending on stage either; there was no attempt to disappear into their larger-than-life characters. They mightily wielded non-naturalistic theatrical tools like dancing and singing, huge hats and platform shoes, and large-scale gestural acting. And they also invented the distancing technique

of irony.

The Great Tragedians were the first-known ironists, and they enacted irony by allowing the audience to know more about the characters than the characters know about themselves, which seems very true, like in real life your friends can clearly see your flaws, your foolishness, they even see what you will suffer, but they can't help you, because even if they had the nerve to disclose their insights, to know something about yourself and then to change, this involves

a readiness.

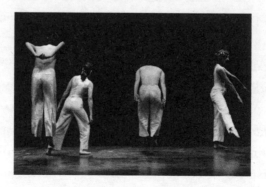

Readiness is insight plus timing. Like in the case of Euripides's King Admetos—all of us seated in the audience can see that in the bargain to sacrifice his wife to save himself, the king has made a horrible mistake, and we want to yell out from the audience to stop him, but he doesn't yet have this readiness, so instead we watch him

fall in slow motion.

When Trisha Brown died, I got mad forever because her obituary underplayed her tremendous contribution to choreography; this nameless critic should be locked in the stocks in the town square for a lack of imagination. Because dance is maddeningly ephemeral, his summation becomes definitive; the liveness, the essence of choreography, essentially disappears if not danced accurately and seasonally, so this obituary becomes a serious matter of error for

the wide shot.

[]

I did some studying and learned that actually Athena didn't turn herself into a spider, she turned an innocent weaver into a spider, and she did this because she was jealous of the weaver's perfect craftsmanship, so she turned the virtuosic weaver into a spider, which is the animal version of a weaver. In my mind, Athena's spider transformation looked like the Louise Bourgeois spider sculpture that I saw at her

MoMA retrospective.

It suddenly occurs to me that Louise Bourgeois's mother worked with tapestries, and I'll ask the god Google later, or I'll ask my friend Suzanne, who is making a performance piece about tapestries, but I am pretty sure Louise Bourgeois's mother repaired tapestries, so maybe, like Athena, Louise Bourgeois transformed her mother the weaver into

a spider.

I found my notes from her show, and on the wall card at the MoMA retrospective, next to the spider sculpture, was a quote from Louise Bourgeois with a long list of immaculate adjectives about her mother and spiders: *"deliberate, clever, patient, smart, neat, useful, reasonable, essential ..."* And though it is usually reductive when art is viewed through a biographical lens, Louise Bourgeois plainly and unmetaphorically states that her mother is a spider, and she builds the image into a monstrous iron sculpture that takes on a life of its own, plus

you can walk under it.

When I visited the criminally belated Louise Bourgeois MoMA retrospective, I audibly gasped as I beheld the first wall of images, and I gasped for reasons of *shape*. I had never seen these recognizably female shapes used as central imagery: these droops, these porous bulges, these unsightly swellings and dripping sags—rendered as no man has ever painted in the long history of men painting

the female shape.

And as I entered the next room I gasped again because I saw a sculpture that perfectly described duality. It was simply a stick of wood and a round wheel, and that's it, that's the sculpture, a wheel and a stick. In my notebook I made a sketch of it and scribbled on my sketch, "Best Friends." A wheel and a stick are fundamental object-beings, but they also reduce to a circle and a line, simple shapes of great oppositional relationality, and basic choreographic elements. What struck me as the truth of this sculpture that I renamed *Best Friends* is the perfect pairing that is vivified in the opposition between the figure of a line and a circle, which speaks to the uncanniness of duality. Plus, it holds interiority

on the surface.

My third audible gasp at the MoMA retrospective was at Louise Bourgeois's charmed spiral hair paintings. In addition to the line and circle, a spiral is a fundamental choreographic element that resonates with nature's spirals, visible in both large-scale spiral weather structures and small-scale spiral petal and shell structures. In dance, the spiral takes you into the center of the room and then deeper into the center of the body, and then returns you out into the large kinesphere of meadows, sky, galaxies—in other words, the widest shot of space itself. And in a perfect pairing of big and little, Louise Bourgeois painted nature's great spirals on

small white handkerchiefs.

And I want to protest also against viewing her work only through the reductive and condescending lens of emotion and psychology, as critics often do with women. I believe they do this to deny women artists the fanfare and bravery of artistic athleticism. Instead, I choose to think of Louise Bourgeois as a brazen and muscular virtuoso with the most

acute telescope.

Regarding a MoMA retrospective, if you are a woman you need to be very old or dead, which is a safely unsexy and unchallenging persona. Even the great painter Hilma af Klint never had a

MoMA retrospective.

Hilma af Klint is usually described first as a mystic and then as a painter, and maybe she was a mystic and that's really interesting, but that's not the point. I mean does history describe Titian or Raphael or Botticelli as a Christian first and then as an oil painter? In the case of Hilma af Klint, the essential point is she broke the form with her abstract large-scale paintings and created

a tsunami.

So instead of being remembered as a groundbreaking maverick and the first abstract painter in the Western world, she is described as a mystic, which is more small-kinesphere and female than being a storm, which is large-kinesphere and male, and all the gatekeepers should be publicly flogged because of this indelible, egregious error in

the wide shot.

When an artist breaks apart familiar structures and reinvents them, there is disruption, and most of the gatekeepers and audiences are disturbed by this, but the audiences and gatekeepers are unaware of what exactly is bothering them, and they just want the artist who is disrupting them to go away. But a few audience people, they crave the re-invention of structure, and these audiences are called "adventurous." I think they have just spent more time

walking in the woods.

This painting is ten feet tall and one hundred years old.

And even though it is virtuosic *and* changed the course of the history of art, this painting was never displayed in an international retrospective until Hilma af Klint had safely been dead for seventy-five years because it disturbed the steadfast structures that were firmly cemented at that time, structures like figurative painting and Christianity, plus it was painted by a woman, so it also disturbed the largest-scale structure, the patriarchy. In other words, it was a metaphorical tsunami, and even though earthquakes are part of nature, if you have a choice, who wants to welcome in a home wrecker? But like in nature, in art-making earthquakes are necessary and positive. Joyce and Cage and Duchamp and Cunningham were all positive and great storm-makers. But what a doubly terrifying tsunami the giant goddesses could manifest, upending many things at once. Imagine what would have happened if in the prime of their lives, when they were young and virile, Louise Bourgeois and Trisha Brown and Hilma af Klint were given the largest-scale platforms

to throw their thunderbolts.

[]

When Paul said *The Odyssey* is pre-interiority, it made me want to confirm that there is also a term *exteriority*—because Homer seems to be telling the story by working the surface like an oil painter, so *exteriority* would be a useful term. I cursorily look up *exteriority*, a word I have been needing, and it seems to be about action, which is satisfying for a choreographer who

loves the surface.

So it bears mentioning that structurally *The Odyssey* is a long-form poem, and at its root, what is supporting, coloring, and driving the narrative involves a formal external rhythm, in this case a strict dactylic hexameter form, which is six beats per line, and Homer leans into this rhythmic structure like

a jazz percussionist.

After many years of kneading poetic structures into choreography, I gave myself the task to rewrite the script of the movie *Terms of Endearment* into multiple poetic forms. Here is a scene where I employ a far simpler poetic form than Homer's—a quatrain:

A:
I've been offered
a job—it's, um,
head of the department,
head of the department.

E:
Why did you not
say this to me?
I need to be
a part of things!

A:
Some time was needed
for to think
before I spoke
to you, my wife.

E:
I really don't want
to move again.
I love the schools …
the pediatrician …

A:
Department Chair!
Department Chair!
How can I say
no way to this?

[]

The day is non-hierarchically composed of light and weight, motion, space, shape, time, and sound—and narrative is just one of many tools we can use to describe it. But because of an obsession with linear storytelling, rather than looking at what else is going on in the text, which may be imagistic, spatial, durational, or rhythmic, the focus remains on the swagger of the story at the expense of the pleasure of these hard-working nonlinear elements. So I ask Paul about the non-narrative elements in *The Odyssey*, and he says, well, there is quite a bit of imagery and that Homer repeats particular images. How often, I ask him, it's uncountable, he says, like the dawn is consistently *rosy fingered* and the sea is always *wine dark*. So I look this up, and learn that this imagery is not considered adjectival; instead, these are formal syllabic structures, but also in their reiteration, the epithets become fundamental to the essence of the noun. And even though I haven't officially read the book, these 3,000-year-old images feel oddly familiar and flat to me,

so I'm like yeah, yeah,

but then Paul tells me about a part when Odysseus and his entourage tie themselves under the bellies of sheep, and I become alert to this image for its strangeness, its impossibility. And then he describes the music in the story, the deathly intoxicating siren song, and the harp that made Odysseus inconsolably weep, and I try to compose these sounds in my mind. And he says that some of the music was so intense and seductive that Odysseus had to put wax in his ears to resist it, and this allows me to reimagine Cage's radical

framing of silence.

And really, I say to Paul, our lives don't operate in a neat cause-and-effect narrative structure, the way we neatly pretzel our lives into these neat linear stories and then neatly defend ourselves against anything that defies our highly constructed neat narrative, and a tell-tale sign of this construct is that the story neatly holds

a single meaning.

On the radio I hear someone talking about how *everyone has a story,* accompanied by a warm, cloying sound cue, as if *having a story* implies both some kind of moral key to who we are personally, and a key to achieving the greater good collectively. And setting aside my issue with the unearned emotionality of the sound cue, I don't think there is a reducible, uncontradictory story. Or I haven't personally found one yet, though

I have been looking.

[]

Paul is lying on the couch talking on the phone to Jack, and he's saying that when Odysseus makes it back to Ithaca and sees that his home is full of greedy suitors partying in *his* house, seated at *his* table, with *his* Penelope, drinking *his* wine— which makes him especially mad, the wine part—rather than getting all swashbuckley, Homer plays with Odysseus's love of deception, secret alliances, and disguise by having Athena

transform his form.

From a tonal standpoint, it's like a Trisha Brown dance. Athena simply turns Odysseus into a beggar, as needed, so he can sneak in unnoticed, because I guess it's assumed that beggars are invisible and small kinesphere. In contrast to the overall swagger of the story, I don't think there would be a splashy sound cue for this beggar transformation, I think the transformation would be done in complete

(silence)

Whoever Homer was, he seems to have begun the enduring narrative tradition of the theatrical stylist with the requisite subject matter of honor and deception, vengeance, and manliness. Of course, Homer wasn't a person; Homer was a performative form of musical storytelling. But isn't it useful and fun to name a whole genre *Homer*? Maybe the genre of postmodern dance should be called Penelope. While Homer is crafty, moody, sweaty, searching, and strutting, Penelope would be cool, direct, plainspoken, formal, factual, unfriendly, intellectual, and

never wear makeup.

Now Paul tells Jack that he feels like he is turning against Homer, he says he is wondering about all this clarity of action, that it feels like it's denying him his own thoughts, and he can't help but compare it to the Old Testament, which is oblique and bizarre but paradoxically and inexplicably relatable—you can feel its meaning in your body, even though that meaning is not abundantly clear. I know what you mean, I say from the kitchen, every year in synagogue when I read the Old Testament, the stories sound vastly different than the last year. Even though the text is unchanged, *you* are different, and the *world* is different, and the text gracefully allows for these shifts, which brings up for me

the triangle.

I always imagine the experience of reading as this: the book is one point on a triangle, the second point on this triangle is you the reader, and the third point is the current state of the world. And these three points are in a dynamic balance. Meaning, whatever you are reading, you experience it through the lens of your own life, plus the world you are living in; and if that world is on fire, the writing may be rendered tone deaf, benign or

especially urgent.

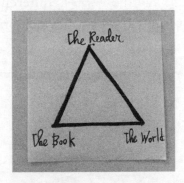

I think it was Brecht who said: *If you do the right thing at the wrong time, you're wrong*, which brings up the matter of timing in creating work as well, because even though we desire artists to be godlike and prophetic, they are just people doing their business, and their combination of insight and lack of insight will align and un-align

as the world shifts.

I was reading *Middlemarch* when George Floyd was murdered, and *Middlemarch* was warped by this fire in the world, and I couldn't relate to the *Middlemarch* characters' needs, dilemmas, or aspirations. In other words, the triangle was

asymmetrical.

In *Middlemarch*, out of the whole book actually there was only one paragraph that I could relate to, and I wept as I read it for its understanding of the emotional power of duality. This part was about an old man who did something really terrible and shamed his family, and having heard the bad news, his wife comes into his room, and she doesn't say anything, but just places

her hand on his hand.

Though this moment in *Middlemarch* is a large-scale event of epic emotionality and transcendence, paradoxically there is no authorial fanfare in the small-scale hand duet George Eliot crafts here. I think with this tiny gesture, George Eliot is addressing the depth and sustenance, the intimacy in

the power of two.

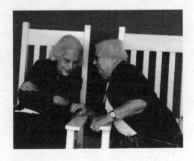

There are so many formidable dualities in your body: your ears sharing the work of listening, your ovaries alternating egg release, the collaboration of your lungs. And these duet structures are echoed in the simple dailiness of our lives, in the perfect need and agreement of buying and selling, and in the duets in friendship, work, and sisterhood.

This is my mom and my aunt.

Rivalries are dualities too and they are underestimated for their generative energy. Like Athena and her jealousy of the perfect weaver, doesn't a great competitor motivate you toward greater excellence as they raise the bar? And it doesn't really matter if you have negative thoughts about the rival, the bar is now raised, and that challenge is ultimately generative and therefore,

a good thing.

I'm in the park walking and it's humid and hot, and I see a dog leaping in my peripheral vision, and I stop to watch a girl throw a stick to the dog, and the dog catches the stick in his mouth, and over and over they dance this duet, a perfect game of agreement, practice and

synchronicity.

But at some point, they stop because it all needs to break, because along with duality, nature includes rupture, change, and error in its dance, and so their loop breaks down, and maybe the loop ends because of the humidity, too. They stop playing, and the girl, still holding the stick—

she just stands there.

We move like nature, we curve and spiral and rotate like shells and cats and snakes, we lunge and dive and bob like wind and lions and waves, we crawl and duck and jump like frogs and drops of water and crabs, we gather and float and pause like leaves and butterflies and oceans. And we stand around. We stand around a lot.

We just stand there.

[]

Last night when Paul and I were cleaning the kitchen together, we heard an interview on the radio with a Greek scholar, and she was asked about the evolution of religious belief. Could she explain the transition from the Hebrew monotheistic god who is intentionally unknowable with no name or image to the classical Greek system where the gods have names, are very knowable and very flawed? The scholar paused—and then she basically dodged the question, which always reminds me of

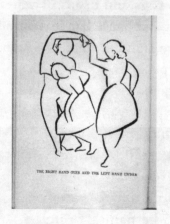

THE RIGHT HAND OVER AND THE LEFT HAND UNDER

that move in square dancing.

Later I hear Paul bringing up this question on the phone with Jack, and Jack says maybe the move toward humanness in the Greek demigods, maybe it's a kind of autonomy, a first step toward atheism, or just agnosticism. I can hear Jack now because the night has cooled off and

the window is open.

And Paul says, given the Ancient Greeks' love of athleticism, maybe this gaggle of demigods was a way to understand virtuosity, maybe they were trying to comprehend why some people are capable of performing so far above the normal range, and Jack says yeah, and he names a pitcher with a dominant slider who even when he's off, he's on, and from the kitchen I say, maybe the Greeks felt better about themselves by making their gods only half-exceptional, so the other half is relatable—bitchy or vain or

taking up too much space.

Some ambulances drive by, so Paul and Jack don't hear me, and anyway their conversation starts to branch into something about the day, mirroring the branches of a tree, or the branching of rivers into streams, or of blood moving through the veins of hands.

This is not a metaphor.

Branching is a compositional element.

And so is braiding.

Structurally, so far, this prose piece has the underlying form of a braid.

[]

The traditional narrative is one where the keen but troubled male protagonist leaves the circle of the home and ventures out on a quest to learn about himself and the world, through the world. And the shape that this quest-narrative takes is a line. A line implies

the infinite unknown.

In *The Odyssey* the overarching line of that quest-narrative exists within a series of durational circle structures. The outer circle is Odysseus leaving his home and finally returning home, but there is a tight interior circle nestled within this of Penelope weaving as she waits at home, and locked inside that circle is the reiterative circular dance of

the hand to the loom.

From a formal/spiritual perspective, the Ancient Greeks considered the circle both perfect and divine, and at some point there was an unsuccessful spiritual movement to overthrow the entire noisy panoply of gods for a single deity that was

simply a sphere.

We all have our shapes.

Oikos, the domestic space of the home, serves as the beginning and endpoint of the outermost narrative circle, but who gets to leave all these tightly wound circles and journey into the "wilderness" (aka self-discovery) and who must remain inside the domestic space needs a shake-up. Penelope, sheltering in place for many years while waiting for her husband's return has earned the right to be the *complicated one,* to encounter her demons and desires on the road, it's her turn to travel in the shape of a line. I bring this up with Paul on a walk. It's still warm out, so we continue to

move our feet to think.

Paul says that the notion of Penelope stopping her weaving, leaving her home, and going out on a solo journey is too radical an idea to imagine. But I say her weaving is only a protection strategy, she no longer needs to weave, let her go out. No, Paul says, I can't imagine it. Why?, I say. Because, he says, it's the way she functions in the story; there are many heroines I *can* imagine breaking out, he says, but she isn't one of them. Well, if you can't imagine it, I say, let Louise Bourgeois and Trisha Brown and Hilma af Klint imagine it for you. Look to them.

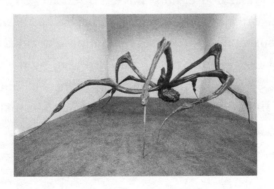

I think in response to our conversation the night before, this morning Paul reads me a poem about Penelope. He reads it very carefully and beautifully. This is the part of the poem I remember:

> I wasn't weaving, I wasn't knitting
> I was writing something

Once, I wrote a text on behalf of the essentially erased seventeenth-century shut-in Elizabeth Pepys, whose husband kept a voluminous diary, recording his days from the quotidian to the perverse. I assumed that Elizabeth, shut up in her house, must have written as well, but after exhaustive research, I discovered her papers had been burned by her husband, so, in belated retaliation, I decided to write on her behalf. At the time I was also reading the work of the dance critic, Jill Johnston, so I wrote this monologue "with" Jill Johnston, meaning I wrote "into" a text by her.

So it was a trio.

A Text Where the Reader Choreographs the Dances in Their Mind as They Read, Because the Dances are Gone,

In Homage to Jill Johnston

Elizabeth, played (coincidentally) by a dancer named Elizabeth:

In my room it's the end of nouns, of names, the end of earth, the end of me, the end of you. There is no end to what there can be an end to it's a great day. But I don't really believe it. Although I believe everything.

(dance)

The last time anybody thought to ask me what I'm doing I said I'm an archaeologist, have you done any digging lately, oh yeah, yes, absolutely yes all the time. Closed up in my room, it's a big excavation site. What a mess.

(dance)

I'm here-- up here in this tower. I'm in every tower I can lay my hands on. I'm running down the spiral stairs, yelling at the top of my lungs. But I regress--

(dance)

Where were we when we last met? Was it Ancient Greece? It must have been a memorable occasion, but I regress, I regress, I received a new dress.

(dance)

And I'm rampaging thru the graveyards of the file cabinets to throw the alphabetized cards into a new beautiful chaos of this mess called civilization. But should we talk about signs and symbols? Let's not.

(dance)

I'm interested in telepathy, thievery, feedback and insoluble puzzles. Since the world is in a convulsion, it seems suitable to talk about these matters. But the house will have to fall down I think. The house'll fall for sure I think. God is around, but she doesn't want to get involved.

(dance)

[]

Later, Paul brings up the circular structures in *The Odyssey* to Jack on the phone, and he tells Jack he is now reading a book (*Three Rings*) about the book (*Mimesis*) about the book (*The Odyssey*), which for me conjures the structure of a spiral—but Paul is talking about light. He's telling Jack he's reading about the distinction between the flat, bright illumination of all things in Homer, and the opaque, shadowy writing in the Hebrew Bible. The effect of the Bible's elusive darkness, he says, is it draws you toward it; in its ambiguity the reader is invited into the loop, to fill in from his own life experience. Yeah, Jack says,

but didn't we have this conversation?

But wait, Paul says, he is thinking now of Penelope's grave and solemn loneliness. Although she was perpetually surrounded by a mob of suitors for many years, she was essentially enduring a form of public isolation,

a solo.

I am listening to them from the kitchen, and I start to realize that all this conversation about Penelope is affecting my choreography. I am in the middle of making a solo in my kitchen, in situ, and though the movement materials of the dance are abstractions of mundane actions we routinely do in the kitchen, like turning on the water in the sink, or setting down a cup, the dance turns out to be surprisingly sad.

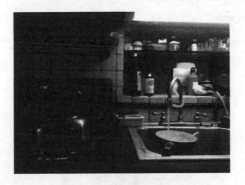

My friend Scott emails me after watching my dance online:

I really liked this! It's so *oikos*.

My friend Jennifer emails me after she watches the dance too, and coincidentally, Jennifer's email mentions *oikos* as well. Jennifer intuitively sends me Anne Carson's essay about an Ancient Greek poem that lays out this paradox of a man setting up his household (*oikos*) alone (*oios*). Anne Carson writes that the Ancient Greek poet uses this paradox to emphasize the solo householder's "radical loneliness." Jennifer says in her email: "the essay makes me think of what solitude enables in terms of radical thought ... living apart from the world in a sense to grow closer to it."

I circle back with this essay to Scott, who incidentally lives alone, and Scott emails me this:

> Ah nice. Ancient wordplay.
> oios = alone
> oikos = household
> It can also mean yogurt.

One day I wake up and realize how many dances I have made in service to circular plays about the male wanderer, the first being Ibsen's *Peer Gynt*. At the beginning of *Peer Gynt* there is a scene I remember as very emotional. On the brink of his journey, the young Peer Gynt leaves his mother at the gate of their hut:

PEER

Well, good-bye then, mother dear! Patience; I'll be back ere
 long.

[Is going, but turns, holds up his finger warningly, and says:]

Careful now, don't wiggle!

[Goes.]

Mr. Rokujō and Hikaru. "I had no pride from
the very beginning."

Five acts later, he returns (circle) as an old man from his extraordinary journey (line), he stumbles through the gate of the lowly hut, and he falls into the arms of a woman (the still point) who is a vague and weird conflation of mother and lover:

PEER
My mother; my wife;
in thy love—oh, there hide me, hide me!
[Clings to her and hides his face in her lap. A long silence. The
sun rises.]

Apparently, she didn't wiggle.

The ring form works like this: ABCBA. It's a chiastic
structure with an emphasis on the center point, followed
by a complete reversal. The more complex and exquisitely
rendered the ring, the more credible and valuable the
prose becomes; the form itself lends the content a gravitas.

Retrograde, the arcane and virtuosic choreographic form
invented by Trisha Brown is essentially the reversal section of
the ring form. In Trisha Brown's retrograde form, you dance
the choreography surgically backward, resisting and upending
the kinetic push forward that the phrase originally had.

My other favorite Trisha Brown structure is called

Lining Up.

The smallest circle in the human kinesphere is your breath cycle, and this sphere widens to the space around your body, then widens to your room, your home, and eventually to the wide shot which is a public kinesphere—the town square, the polis, the city.

That was a transitional bridge.

There is a public square in London that actually measures as a perfect square, and standing in it one morning, I observed a serene scene of public cohabitation, as solos, duets and trios of people reading and talking and eating drifted in and out. And in my body I could feel the square's elegant dimensional equality holding these valuable quotidian movements, as the sides of the square looked in on themselves in a kind of unison, and its perfect proportionality

glowed.

The act of taking over the public square to express political demands through protest is an ancient, sacred, and protected act. Occupy Wall Street took over a square, a city block, forming a utopian town, replete with doctor and library, school and bed. Lasting months, it was a leaderless stroke of disciplined theatrics combining a way of living, a sensibility and a politics. It was also a

durational dance.

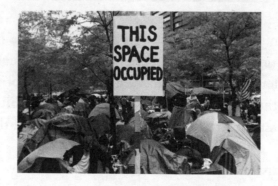

The ownership, the demand that citizens can reframe the use of the land to express a political idea with their bodies in turn decentralizes and theoretically democratizes the notion of theater, moving theater out of the transactional space of the stage and into the streets. Marches, lie-ins, sit-ins dictate the tonality, muscularity, and movements of the body with intentional meaning; here form and content are joined to create change through spectacle. These public acts in the public space are designed for easy execution and comprehension by the performers and watchers alike—

no dance training necessary.

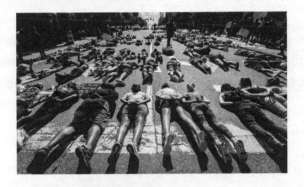

These acts of protest are choreographies: the body in space has intentional directives agreed upon by the performers. If for example the prop of a gun is incorporated into a protest, the tonality of the event is explicitly different than say a lie-in, and everyone agrees on how to

perform that ritual.

[]

When Donald Trump lost his job, I learned the news through the window; there was yelling and cheering coming through my window and I heard the cheers and thought:

now what is that?

And I opened the window and the sound came crashing in, and I realized that Trump had lost, and I learned this through the ancient form of citizens raising their voices in joy.

And we went out to the street and we lifted our arms and cheered, and we jumped up and down and said Whoop! and Yay! and OOO! We were laughing and punching our arms in the air, into the high space, a female space of vulnerability and love, and we were looking into the eyes of strangers and our eyes were filled with tears all day, and we were weeping and laughing with people we didn't know, and because of the pandemic we still had to maintain our six feet distance, but that was okay, and that's a lot of choreographic directives all at once and everyone did them perfectly in a spontaneous beautiful unison of spirit that I had never seen before and no one had ever executed before, but everyone moved perfectly because this dance had been inside of us since

the beginning of time.

When Donald Trump lost his job, there was large-scale spontaneous theater all across the country, a great fanfare, a raising of voices and dancing in the streets, and these dances were as natural as a leaf growing on a tree, and the trees were dancing too in reciprocity of

the joy of the city.

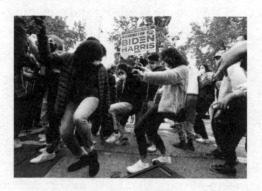

Long before Trisha Brown, before ballet, before disco dances and round dances and square dances, there was ecstatic dancing, and here ecstatic dancing was spontaneously happening in the twenty-first century. We are still fundamentally the same, I thought. We are essentially a body in space with other bodies, expressing how we feel through

our dances.

[]

In my friend Suzanne's loft, Paul and I stage a reading of Anne Carson's adaptation of Sophocles's *Antigone*. Anne Carson has suggested I cut her text to ten minutes. Why? I ask. Because theater is too long, she says. So I do a brutal edit, and Anne says, "It's fine," and we ask the choreographer Yvonne Rainer to read the part of King Creon because I love the tone of her voice, and Yvonne responds by saying, "Why not?" Yvonne arrives wearing a large, flashy gold necklace, which I think is a reference to kings, and Suzanne dresses her in a fur stole and a Shriner's apron, so visually and vocally it's already very interesting, the surface is very alive—and then we read the play. By the end of the play, because of Yvonne's grave yet plain-spoken performance, it is as if I am hearing Sophocles for the first time, and it occurs to me that what happens to Creon at the end of the play is truly our greatest fear: that our decisions and actions could completely annihilate our family. In fact, I sense our entire audience is quite shaken up by a realization of

this terrible power.

Later Yvonne sends me an email:

As I tried to express briefly afterwards ... bringing emotional affect to such readings is something I would have thought myself incapable of, having flunked out of the acting classes I took in the 1950s. Stanislavski was not for me. But something happened,

lo and behold.

That night I dreamed that Anne Carson was pointing inside her mouth and weeping, she was showing me the base of her mouth, and then she lay down, and I lay down next to her, and she pointed again to the inside of her mouth and I could see that her mouth was caving in; the base of her mouth had collapsed, and she was weeping and pointing, and I knew she was crying for the structure of her artistic voice, because the base of it was

falling apart.

And when I woke up, I realized that I had dreamt about poetics and how organic they are, that poetics are a natural phenomenon, because while I was asleep, I was employing one of the greatest tools of art-making to express an idea: the metaphor, which means that art-making is so natural to our biology that we are actually using formal artistic tools

in our sleep.

This is not a metaphor.

I am wondering if the Great Tragedians saw their work as
great and tragic. I really don't think Euripides would like
this extravagant epithet and I say that with some sureness,
not just because I have made many dances for his great and
tragic plays, but also because of the nature of his writing, I
feel like I personally know him, like you know a friend, like I
know what he is feeling—or would feel. I myself am familiar
with grief and Euripides has written several plays on this
subject, and if it's true that we read to understand ourselves
and how to live, that would explain this deep connection
I feel with his writing. He writes about grief as a man in
mourning, a man suffering a profound regret. Even 2,500
years later, no writer rivals Euripides's insight and nuance
on the subject of grief. I mean I realize that's a big splashy
statement, with a tone of fanfare that is very un-Trisha,
and I say that knowing of course there is so much I haven't
read, like I haven't read *The Odyssey* and I don't think I will,
because when Paul reads something I kind of feel like I read it,

same with him to me.

Once I heard on the radio that the characters in the books you read become real memories in your mind alongside the real people you have spent time with, and even though they are fictional, they lodge in your memory and get mixed with the real people, like your mother and father get mixed with

Bartleby the Scrivener.

Plus, I have felt this while walking down the street, that the poems you memorize become rhythms in your steps; I have walked to the rhythms of the poets my mother read to me: Elizabeth Barrett Browning and James Whitcomb Riley and Edna St. Vincent Millay, they are in my step:

> *LITTLE ORPHAN ANNIE*,
> STEP STEP STEP STEP
> *HAS COME TO OUR HOUSE TO STAY*,
> STEP STEP STEP STEP
> *TO WIPE THE CUPS AND SAUCERS*
> STEP STEP STEP STEP
> *AND BRUSH THE CRUMBS AWAY*
> STEP STEP STEP STEP.

And I think this is true, that the real people and the fictional people and the rhythms of the poems you know by heart all get mixed in your mind and your body. From a formal perspective, that sounds like a

nonlinear gem structure.

[]

Ten years ago in my favorite neighborhood bookstore, a bookstore that was central to my emotional, artistic, and intellectual dailiness and has since transformed without fanfare into a corporate coffeeshop, which is an oxymoron— at this bookstore I witnessed Anne Carson, in an intentional and successful theatrical gesture, throw her accordion-pleated book, the book about the loss of her brother,

across the room.

If you translate dance into parts of speech, *motion* is all verbs, so that night in the bookstore when Anne Carson threw her book, she *shifted* her weight forward onto her front foot, and *extended* her arm in a large-kinesphere *curving* action, *opened* her hand, and her book *danced*

across the room.

Across the room is a choreographic directive because it tells you where to move. Choreographic directives are everywhere. I once made a dance for a Greek play using the Mapquest directions from Ithaca, NY, to Troy, NY, as a score. I also have made a dance from street signs, and though the physical actions on the street signs overall were in a small to mid-range kinesphere, the dance as a whole ended up being epic and exhaustive, because in matters of choreography, when I am not distilling down to erasure, I tend to be

a durational completist.

Once in that same bookstore, now closed, I heard a young author, who was also a comedian, use a phrase that stuck with me; I heard it, I remembered it, but I never wrote it down. Here, I type out the phrase once and for all, and take a look at it:

the flower-strewn median strip on the highway of my mind

The young comedian/author's contention was that if you added the phrase *of my mind* to the end of any sentence, the sentence would take on mythic, indeed hallucinogenic proportions, so from a choreographic perspective, simply by ending with *of my mind*, the sentence holds this paradox of a large-scale event in the small-scale theater of your head, and because he was a comedian, I think he was also

being ironic.

Trying to define the word *irony* is as slippery as a live fish in your hand. I think it was Milan Kundera, an author I fervently read in the 1980s but whose novels may be in an asymmetrical triangle situation with his readership at this moment, I think it was Kundera who wrote that the definition of irony is *one eye crying and the other eye watching that tear fall*, a perfect image of the mind's odd ability to be self-aware, even in times of deepest sorrow.

But as to the *flower-strewn median strip on the highway of my mind*, I think this phrase stuck with me because it places the weightlessness of flowers next to speeding cars, which suggests that what you hold onto in your mind may have more to do with the power of vivid imagery, like petals and concrete, than things that are of practical importance which may just

float away.

I wish I could etch some of Euripides's lines onto my own flower-strewn median strip, lines like this one:

The master cannot know this yet, until he has suffered it.

I think he is addressing emotional/physical states you literally know nothing about until you have experienced them, states like how your body feels when you lose a child. You can empathize, but you can't *know* it until

you have *suffered it.*

But conversely I wish you could decide what to erase as well, the things in your memory that still bleed, but of course such an erasure would make no sense in terms of the natural truth of contrasting dualities. I know this, but I still wish you had the power to erase them from

your median strip.

In 1953 Robert Rauschenberg asked Willem de Kooning if he would give him a drawing to erase. And de Kooning challenged him by giving him "a very good one" and one that would be particularly "difficult to erase." In this work, *Erased de Kooning Drawing*, Robert Rauschenberg was playing with the notion of making something new from an action of negation and deletion. But Robert Rauschenberg was also attempting to create space for himself through the action of

erasing the master.

Some years ago, wanting to work with Igor Stravinsky's experimental, complex, and folkloric music, I almost killed myself and five very good dancers wrestling with Stravinsky's *Les Noces*. *Les Noces* was firstly and brilliantly choreographed by Bronislava Nijinska, the genius and lesser-known sister of Najinsky. Yet however earnest and diligent I may have been in this pursuit of making a dance to *Les Noces*, my esteemed teacher pointed out to me that I was working in the shadow of a panoply of choreographic virtuosos who had attempted to unlock the secret box of Igor Stravinsky as well, and she strongly counselled me against such a probable comparison. In response to my teacher's dire warning, I returned with the five dancers to the studio with a new choreographic idea: I would slavishly maintain my original choreography, including Stravinsky's intricate rhythms, the uncountable phrasings, the choleric accents, and the complex relationalities, but we would *not* dance to Stravinsky's music. Instead I changed the music to rock and roll. So, essentially,

I erased Stravinsky.

[]

Paul says in his book now that Odysseus is hanging
out around the suitors in his beggar disguise, it's going
well, he's getting some intel and no one recognizes him
thanks to Athena's gift of a disguise, plus he is probably
using small-scale actions because he's blending in, until
his old dog sees him, the dog comes right up to the
beggar, and the dog smells him and instantly knows
who he is. And there is a suspenseful moment, Paul says,
where you feel like the dog is going to give it away, but
then, in a splashy and quick-tempo theatrical gesture,

the dog dies.

Maybe Homer started it, but it's an old narrative device that
if you need to get rid of someone you just kill them off, like
you kill off the mother so you can have a father/son movie or
whatever, so Homer kills off the dog to save Odysseus, and
Paul says since no one noticed him but the dog maybe it stems
from class bias to ignore the beggar, and dogs of course don't
know anything about class bias, but they do seem highly aware
of sticks and leashes, so it's sad when someone trains their dog

to get their own leash.

[]

In the book that Anne Carson flung across the room that night, in the bookstore now closed, she reflects on the loss of her brother by way of the brief elegiac poem by Catullus, titled "#101," a 2,000-year-old ten-line poem of grief about the loss of Catullus's brother. I need to ask the Google-gods if my memory is correct, that the poem is really only ten lines long, because in dance, these matters of scale and duration are essential expressive tools. As to the title, #101, the tonality is both coolly beautiful and

simply indexical.

Once I went to a Q and A where the questioner asked the choreographer Douglas Dunn about the inspiration for his dance piece. Well, he said when the curator approached him originally, she asked him to make a twenty-minute dance, so he started devising a twenty-minute dance, and then a few weeks later she called him on the phone and said she had added another artist to the program, so make it a fifteen-minute dance instead. Okay, Douglas Dunn said, and he hung up the phone, went back into the studio and

he started all over.

Why, the curator asked, why did you have to begin again, why not shorten the existing material? Well, he said, he had to start all over because a fifteen-minute dance is unrelated to a twenty-minute dance. He said:

duration has meaning.

In the case of Catullus and his ten-line poem on the death of his brother, the duration and scale of the poem is a perfect form/content construct. On the subject matter of death, brevity feels precise and salient, plus death's kinesphere is an unknown, I mean we experience others' deaths as large-scale events, but maybe our own won't be a matter of such epic proportions; from the inside, it may be a quick, quiet,

gradient fade.

I got an email from my friend Suzanne. She is emptying her deceased mother's house in Texas:

> The hard part was just deciding what to take.
> I debated about a little Christmas tree Mom made out of
> coke cans and spray-painted gold.
> I mean I don't like it or anything—but she made it!!
> And I've seen it all my life.
> My sister and Thea were just shaking their heads.
> They couldn't believe I'd even consider it.
> The very last day at the very last moment I realized I could
> make a hat out of it.
> Thea announced—"ok, she's taking it now."
> I ran to UPS and had them pack it up to ship.
> Too big for my suitcase.

One day in Durham, NC, my choreography teacher said to me while standing in a dark theater at a technical rehearsal:

"We make more of death than death makes of us."

From a choreographic perspective, that's a back/front mirroring,

plus this teacher was very old, so she was, from a time/space perspective, proximate to death.

This is a picture of a piece of choreography I made for a musician who loves to dance. He is in his late sixties, and I choreographed this with the idea that while maintaining his innate dignity, he could give up his weight to others. Here, issues of density, authority, and touch hover around the image, and the closeness of space between the performers suggests the duality

of care and trust.

It took me many decades, but I finally made a dance based on my love of Balanchine's stark, angular mid-century neoclassic period. I named it *Ballet*, and unbeknownst to me, Trisha Brown had made a dance in 1968 with the same name, so my dance was an unconscious homage to Trisha Brown as well, which makes good dance sense from a structural lineage / branching perspective. But for some reason, and I find it inexplicably moving, this also now makes me realize that

Euripides read *The Odyssey*.

My dance ended with a ballet in heaven.

Dancers leave the stage to a voiceover of Siri:

And pretty soon ballet itself will float into the high space of the heavens, and it will disperse into micro data. And the data will mix with every angel and soul and lost love, and everything good and sad. And maybe, up in the sky, the ballet data will be reunited with George Balanchine. And he will probably be in rehearsal like he always was, preparing a ballet, making a new dance for the people who we once loved, but are now gone, dancing on a stage beyond our perception.

[]

I break down and decide to read *The Odyssey* and I am immediately struck by its emotionality! There are so many tears, I say to Paul, starting with the very first time we meet Odysseus where he is described as weeping inconsolably. There are so many tears in the book that it seems like a reiterative motif, so I compile a partial list of all the tears mentioned in the text and put them into a block structure, and I read it to Paul:

Dissolving in tears, bursting in tears, indulging in tears, brushing tears away, tears streamed down his cheek, a flood of tears, tears flooding his eyes, spells of grief, storms of tears, tears overwhelm, blinding tears, blinding tears, my tears, her tears, his tears, shedding tears, wiping his tears, melted into tears, tears of heartbreak, throbbing sorrow, streaming tears, wailing and streaming live tears, waiting in tears, begging with tears, tears welled up in his eyes, painful longing for tears, weeping live warm tears, hot tears, streaming tears, river of tears, face wet with tears, broke into tears, tears of grief, wiping their tears, groaning in grief and tears, her bitter tears, cheeks streaked with tears, drown in tears, cheeks rivering tears, broke into tears, weeping live warm tears, knelt down and wept, how long must you weep, how bitterly they wept, he wept, he wept tears for the one he lost.

In the final scene Odysseus can't bear that his father is wrapped in a "cloud of black grief" so he drops his disguise, throws his arms around his father, and kisses him, and here in beautifully rendered and earned emotionality, this figure from 3,000 years ago completely comes alive for me, my heart wakes up to who he is. Yes, it's very immediate, Paul says, for me it's like this part in the book when the goddess who is in love with Odysseus offers him this bargain: you can live forever but you have to stay with me on this island, and Paul says that when he read this part, it reminded him of September 11, when he was marooned at a college in New Jersey, unable to get in touch with us, and staring at an empty football field he thought: I would rather be with Annie and Jack and die, than be

safe but separated.

Here is a picture of another dance I made; this one utilizes a wide, even, six-foot separation between the performers on a rectangular stage.

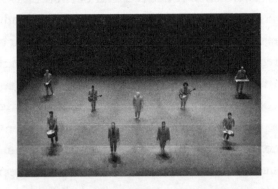

To my eye, it's an elegant proximity.

Paradoxically, the spacing was inspired at dinner one night by looking at an ear of corn.

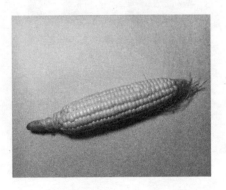

Nature uses complex formal spatial structures, and without knowing it, we are mirroring them as we move through the day. An *array* is an example of a spatial pattern of reiteration, a glorious and economic use of space. Bees use array patterns in their honeycombs. Trees form a spatial understanding with other trees in their tree communities; the reach of their branches is an agreement for the greater good of proximate trees. We do it too. We are space-makers, we are natural choreographers as we craft our paths and proximities. All day long we tacitly and spontaneously make decisions about how much space we need between one another; we place chairs, tables, and bodies in physical relationships that we find emotionally and somatically appropriate for our desires. We stand apart from strangers, but close to those we love or want to love. We are always negotiating these

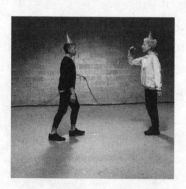

issues of distance

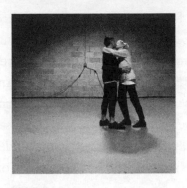

and nearness.

[]

Living through a pandemic changes our relationship to space and liveness, everything from going on an errand to the meaning of presence itself. A pandemic demands that we, we pedestrians, bodies in the public space, that we dance together differently. On the stage of the street, the citizen body has entered a dynamic period of rechoreographing as it moves through space and time.

[Here, in this space, evenly clap or tap: 1, 2, 3, 4.]

This dance has a revised series of choreographic directives. The primary pandemic choreographic directive concerns the space between you and the other dancers in the public square.

[Again, clap or tap: 1, 2, 3, 4.]

The measure of this distance is called a fathom. A fathom is 1.8 meters in Europe, and six feet in the United States, and I think a fathom usually measures the depth of water, but when it's a verb, it can describe the process of untangling something in your mind. Or it could mean a hard thing to

[Again: 1, 2, 3, 4.]

imagine.

The citizen body is learning spatial awareness; spatial awareness is now as common as grass, and the entire world is performing a dance of proximity together. Fathom the entire world standing six feet

[1, 2, 3, 4]

apart.

In the state of Maine, a fathom is pictured as the length of a moose. In the state of Florida, they picture an alligator. In Colorado, it's the length of a ski. In China, it's a tenth-century hat with long wings attached like a gull. In New York City, it's the width of a yellow taxi. These are regional images to help us find our fathom.

[1, 2, 3, 4]

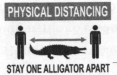

The stage for the dance is the store and the street. We practice our fathom as we purchase and pass. At first our movements are like squirrels and bandits, but later our movements are like deer or skaters. And sometimes we stand in a line on pieces of tape marked with an X.

[1, 2, 3, 4]

We stand dutifully on our X, like children being good, and we are good for the greater good, which is the phase we are in when we feel civic empathy. And everyone's hair is blowing in the dance; we like hair and air that is blowing because we fathom our air loaded with something dense and invisible from which to dodge and to bend.

[1, 2, 3, 4]

Or we stay inside. When we used to stay inside, we used to be home. But if we stay inside during the pandemic, we are sheltering in place. *To shelter in place*, it's a choreographic directive that implies stillness, and our apartment becomes a shelter, which sounds very gentle. In my mind's eye, Paul and I are in a little cabin standing very still surrounded by a city on fire.

[1, 2, 3, 4]

The entire citizen body is directed to wear a mask. In March, this small costume is made of stapled paper towels and rubber bands! In April, it's stitched from rags from our rag bag. My favorite one I made from my Mom's maroon Jethro Tull T-shirt from the '80s.

(Here I break the form to say a silent prayer to my mother.)

In April in the late afternoon we sit in our shelter and sew by hand, at the kitchen table we sew and listen to the governor on the radio as the infection numbers rise. Now it is May and this cloth face covering can be bought on the street, and in our city, everyone is wearing one; our faces have gained an adaptation of an erased mouth and nose so it's hard to know what anyone thinks, but we as a city are proud of

[1, 2, 3, 4]

adhering to our directive. It is June and our costume is now weaponized and politicized, but it's just a small bit of fabric with two ties, and costs almost nothing.

As to the choreographic element of time,

[1, 2, 3, 4, 5]

the duration of the dance must be less than fifteen minutes.

[1, 2, 3, 4, 5, 6, 7, 8, 9, 10, 11, 12, 13, 14]

But when the cast of our dance is made up of strangers, and the air is blowing, and the dance is brief, and we are wearing our costume, and the strangers glide in a proximate motion, and there is a moose or an alligator between us, our dance feels simple.

[1, 2, 3]

But if our dance is with friends, because we are friends, to the form we add content, and we improvise pitiful and odd arm gestures, and the dance now holds issues of trust and longing, and we notice an urge to create variations to the directives. And because we are friends, the fathom is electrified with an urge to defy the choreographic directives, so the fathom shrinks to show our love, and the costume disappears to show our trust, because we are friends.

[1]

Wasn't there a dance of death in medieval times? Wasn't it an ecstatic dance? Or was it the nervous system reacting to a virus and it was called a dance? I'm not sure, but I don't want to look it up, I am tired of opening my computer to know things. The day is already too virtual to look up something as embodied and important and beautiful as a

dance.

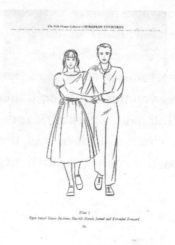

The Folk Dance Library—EUROPEAN COUNTRIES

Plate 3
Open Social Dance Position, Outside Hands Joined and Extended Forward
73.

[]

My rabbi and I exchange some emails on the subject of minyans in the time of a pandemic. A minyan is a physical gathering of ten people in space, which for thousands of years was a rabbinic necessity in order to chant certain holy prayers. Think of the implications of necessitating a gathering of bodies in space in order

to reach the divine.

My rabbi says that the minyan has now essentially been rabbinically ordained to occur in a virtual platform called Zoom. Wait, I say, this constitutes a radical redefinition of presence and liveness, I say. He says that the rabbis reached this decision through interpreting references in the ancient texts, and then he emailed me an article about it. In the article the rabbis cite Talmudic interpretations of proximity, citations that are both deliciously arcane and choreographic. These Talmudic discussions address ancient alternatives to proximate gathering, like the chanting of sacred prayers in a field, chanting loud enough that someone far away can hear you, or through a window where your face can be seen, and as to the window example, the Talmud specifically advises a window that is

four cubits wide.

I looked up the length of a cubit, and in the Old Testament it's the length from the tip of your finger to your elbow. I make a note to myself that the next time I go into a theater to measure the stage and forget my measuring tape, I can do it in biblical cubits, plus it sounds like four cubits

equal a fathom.

The most important prayer that is said in the minyan is the memorial prayer that mourners chant, a prayer that is believed to benefit both you and the dead, implying a mind-blowing reciprocity between this world and the next. I think the rabbis are basically punting here for health reasons when they determined that if you can't shout the prayer in a field, or gather ten people through a four-cubit window, the window could be reinterpreted as a

Zoom window.

But, the rabbis continue, and this is my favorite part, if none of this is emotionally, technically or physically possible, instead of chanting the mourner's prayer, you can instead perform a different sacred act; you can honor your beloved dead just by

reading a book.

[]

Even before I had read *The Odyssey*, I was aware that the Old
Nurse bathes the "beggar's" feet with oils, which seems like a
spiritual act of solemnity and goodness, touch and proximity,
but that's not the main point, Paul says, because while bathing
him with oils, Old Nurse recognizes a scar on his leg and
instantly knows it is Odysseus, but she doesn't instantly die
like the dog. Instead, Homer writes that she instantly drops
his leg in surprise. It's the same kind of time-based rhythmic
gesture though, and it rhymes with the dog dropping dead,
but the authorial choice is small-kinesphere, less splashy

and more Trisha.

I knew about the Old Nurse and the scar because it's in
the collective imagination, and I'll consult the Google-
gods later, but I think the collective imagination is the
flower-strewn median strip on the highway of the *whole
world's* mind, and even though this collection of memories
is uncurated, to enter the collective imagination, you still
have to have made it into the wide shot in the first place.
If I could, I would like to add Trisha Brown's dance to the
collective imagination, the dance where she tells two stories
and dances two dances simultaneously, because it's the only
piece of art I have ever seen that perfectly expresses the act
of thinking, but you can't just add things to the collective
memory, and that's why Louise Bourgeois and Trisha
Brown and Hilma af Klint not gaining early and earned
access to the widest of the wide shots is a problem that is

unerasable.

[]

These days instead of entering the live theatrical space, we can stay in our huts and asymmetrically watch a dance alone on our computer, rendering the visceral into the virtual. But I am not sure, when you take away the liveness, without a physical sharing of kinetic energy between audience and performer, I am not sure it's dance anymore, but I don't know what to call it. Like nature, dance is a dynamic process, and now as it is organically changing into something non-live, it's taking on new poetics.

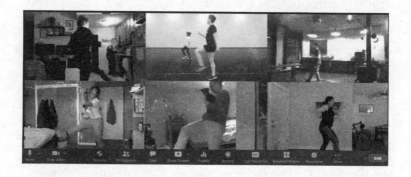

Zoom is a folk art form.

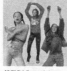 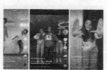 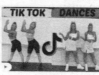

10 TikTok Dances to Learn
thecut.com

Best TikTok Dances of 2020 So Far | Time
time.com

NEW BEST TIK TOK DANCE TRENDS! | The ...
youtube.com

20 Top TikTok Dances: 'Renegade,...
insider.com

So is TikTok.

Form both holds and creates meaning, and the meanings of the poetics of each social media form are governed by a particular syntax, evolving in real time. Zoom is a geometric box form with the chat feature serving as Chekhovian side conversations. TikTok is an *oikos* micro—folk dance in thirty seconds, eliciting bursts of amateur communal dance material with bedroom as stage. Twitter with 280 characters is a terse rant, a soapbox form, lending itself to snark, idiosyncrasy, and fragmentation. Instagram is a theater of images. Email replaces

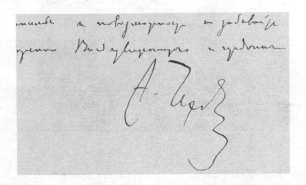

the letter.

Once, the letter was a ubiquitous time-based hand dance in a chain structure with many parts. Here is its choreographic score: to write by hand, to fold, insert, seal, and then post by hand, to deliver from hand to hand, to then receive and open and unfold by hand, and finally, as you read, to hold this letter in your hand. And these hand actions would be durational, stretched over time and distance, affecting both the creation and reception of the content, and rendering a loop of meaning between the sender and recipient.

Chekhov signed his letters with this embodied gesture:

I press your hand warmly,
 A. Chekhov

The Ancient Greeks used the technology of pots for their social media, and from a poetics perspective, their pots were

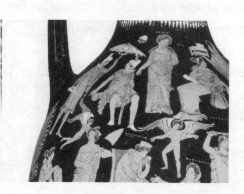

Instagram.

There is a pot that survives from 430 BC and it shows Penelope resting at her loom, which seems fair. For thousands of years Penelope has been depicted by artists and writers as *deliberate, clever, patient, smart, neat, useful, reasonable, essential.*

But when I think of Penelope, I imagine a boisterous men's group dance,

with Penelope in the center,

silently and efficiently dancing a small-scale, repetitive, asymbolic gestural solo

in retrograde.

In a sense, social media forms are performative solo forms with an odd conflation of friendship and marketing; the body is alone in a room performing the self, with an undercurrent of desire for applause. Without a town square to gather in and hash out the day with neighbors, social media communications have a shading of loneliness

underneath.

But the solo form also has implications of courage and solitude, a heightened awareness and acuity central to the solo journey, like Louise Bourgeois, Trisha Brown, or Hilma af Klint, rewriting the rules, changing the game,

alone.

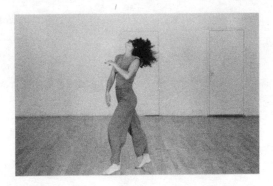

[]

I hear Paul talking to Jack, and he is saying something about the way Homer uses time, the way Homer stays completely in the present tense even when he is describing the past. Like in the case of the foot drop incident, he says, everything is perfectly clear and fully lit; no foreground, yeah Jack says, no background, yeah Jack says, yeah. Paul says compare that to the story of the sacrifice of Isaac, you know that incident, yeah, of course, Jack says, in that story we don't even know where they are. Abraham's existence is only relevant in relation to the voice of God—no time, no space, yeah, Jack says, no landscape, just walking, just steps; there are some objects, some sticks, yeah, Jack says, and a knife, yeah, yeah, Jack says, and those objects only are present to fulfill God's commandment, everything serves this sacred act, and nothing else exists. One second, Dad, Jack says, I want to respond, but I'm trying

to park the car.

There is a long pause. Paul, still holding the phone, picks up a book, reads a bit, puts the book down.

I hear Jack's voice again, yeah in the Bible, Jack says, you can't even write God's name, but in *The Odyssey* it's all right there, everything is articulated; so in the Old Testament, Paul says, your imagination is challenged to see into the shadows, to render what's missing—interesting, Jack says, clarity vs. obscurity, Jack pauses, but a story about testing someone's faith—well in *The Odyssey* that would never happen, it's just like yeah it's a given, Zeus's authority is unexamined, a given. But in the Hebrew Bible, Paul says, God is brutally insecure, always asking for proof of belief, sacrifice your son, prove your faith to me, God is perpetually agonized. Yeah, Jack says, maybe our culture of anxiety grew out of that, but one second Dad, I need

to pay the meter.

Hold on, he says, and Paul picks up his book again, as Jack somewhere performs an act of dailiness, a small-kinesphere quotidian set of asymmetrical actions with many parts, a solo.

[]

The wide shot is the camera position that allows the audience to see the full body of everyone in the scene in their environment, it's the most objective and potentially the most compositional of camera positions, and for very brief moments I can perceive our wide shot: that we experience contentment, then we suffer, we slog through what we deem uninteresting, we get inspired, we see things, we miss things, we trip or fall or slowly crumble, we get up, we fight, we reconnect, and then in despair or fascination or just reflexively,

we write about it.

And this desire to articulate what you feel and perceive, to tell it, to name it, to describe it, this is as natural as the progression from walking to running to leaping, to shaping that leap into a pattern of leaps, and then a group of leapers in unison—into

a dance.

And if I go into the extreme wide shot, I can see a generative duality between us and the world, a reciprocity between us perceiving the world together through art, and the world in turn reading *us* through what we make. In this mirror structure, I can imagine the creative act as world-actualization rather than self-actualization, that what *we* make becomes a part of nature's

generative system.

[]

Paul calls Jack to tell him that he finished *The Odyssey*. The end is very amusing to me, Paul says, it's so pagan, so fiercely pre-Christian. Basically he says what happens is that the families of the suitors who Odysseus killed, they return in vengeance, so Odysseus, his son, and his father fight them off together. And Odysseus's father says something like, *how can I possibly be happier, I am here killing people with my son and grandson!* And it ends with the family reunited happily slaughtering people, ha ha, Jack says, that sounds like a *Simpsons* episode.

Paul says yeah, it's a far cry from the commandment: *Thou shalt not kill.* Yeah, Jack says, it makes you realize how important it was to articulate that idea! I hear Paul laughing, yeah, the ten commandments didn't come soon enough, Jack says something I can't make out, but I can hear his deep voice, Paul says yeah, we've moved from collective homicide to collective suicide, and Jack says, but environmental destruction seems less directly intentional. Okay, Paul says, but even if it's not intended—it's insane and psychotic.

The AC is on high, and though I can't hear everything Jack is saying now, I can feel the perfect symmetry of their conversation, which I experience as peaceful for its balance, a loop of energy winding around, creating a spiral of devotion. Theirs is a stick and a circle, a duality that makes each one lighter, more durable, and more

[]

resplendent.

Acknowledgments

Thank you to Jessie Kindig for her creative spirit and for her intuitive, generative prompt: "Just write something …" Thank you to Ilana Khanin for her scholarship and mutual love of back matter. Thank you to Jack for his inspiring generosity of spirit. Thank you to Paul for living through this book, and many other creative experiences, by my side.

Visual Sources

1. Photo: Annie-B Parson.
2. Quotation by Fernando Pessoa. Post-it.
3. Drawing: Annie-B Parson.
4. Photo: Annie-B Parson.
5. Krishna's Ring Dance, Jaipur, about 1800. Mohinder Singh Randhawa, *Indian Painting*. Houghton Mifflin Co., 1968, 114.
6. Shalmaneser III greets Marduk-zakir-shumi, Throne Dais of Shalmaneser III (detail) at the Iraq Museum. Photo: Osama Shukir Muhammed Amin.
7. Post-it.
8. *The Cholmondeley Ladies*, artist unknown, 1600–1610. Postcard, personal collection.
9. Drawing: Annie-B Parson.
10. Choreography by Trisha Brown, photo of Trisha Brown Dance Company in *Locus*, 1975. © Lois Greenfield.
11. Screenshot by author.
12. Hilma af Klint, *The Ten Largest*, No. 2. Postcard, personal collection.
13. Drawing: Annie-B Parson.
14. Photo: Annie-B Parson.
15. Drawing: Annie-B Parson.
16. Post-it.
17. Post-it.
18. Gavotte de Pont-Aven folk dance illustration. Anne Schley Duggan, Jeannette Schlottmann, and Abbie Rutledge, *Folk Dances of European Countries*. A.S. Barnes and Co., 1948, 137.
19. Fantin-Latour, *La Lecture* (detail). Postcard, personal collection.

20. Barbara Parson (left) and Caroline Goldbach. Photo: Annie-B Parson.
21. Photo: Jos Demme.
22. *Roe Deer with Buck Deer*. Photo: johan10 via Getty Images.
23. Quadrille dance illustration. Grace L. Ryan, *Dances of Our Pioneers*. A.S. Barnes & Co., 1939, 50.
24. Photo: Annie-B Parson.
25. The Hand. Henry Gray, *Gray's Anatomy*. Bounty Books, 1977, 403.
26. Screenshot by author.
27. *Way through the Fog*. Photo: Michael Schauer. Postcard.
28. Louise Bourgeois in 1975 wearing her latex sculpture Avenza (1968–1969), which became part of Confrontation (1978). Photo: Mark Setteducati © The Easton Foundation/VAGA at Artists Rights Society, New York.
29. Walking steps. Arthur Murray, *How to Become a Good Dancer*. Simon & Schuster, 1938, 34.
30. Louise Bourgeois, *Crouching Spider*, 2003. Bronze, silver nitrate patina, and stainless steel: 106½ × 329 × 247 inches; 270.5 v 835.6 × 627.3 cm. Photo: Christopher Burke © The Easton Foundation/VAGA at Artists Rights Society, New York.
31. Jill Johnston/Parson, monologue for Elizabeth Pepys.
32. Steps in a circle. Arthur Murray, *How to Become a Good Dancer*. Simon & Schuster, 1938, 41.
33. Photo: Annie-B Parson.
34. Photo: Annie-B Parson.
35. Photo *of The Lady Aoi*. Yukio Mishima, *Five Modern Nō Plays*. Charles E. Tuttle, 1986, 169.
36. Photo of *The Lady Aoi* (detail). Yukio Mishima, *Five Modern Nō Plays*. Charles E. Tuttle, 1986, 169.
37. Trisha Brown's *Group Accumulation in Central Park*. Copyright © 1973 Babette Mangolte, all rights of reproduction reserved.
38. Voters wait in line. Screenshot by author.
39. This space is occupied. Screenshot by author.
40. A lie-in demonstration. Screenshot by author.
41. Photo: Annie-B Parson.
42. Dancing in the street. Photo: Erica Schwartz, *Seattle Times*. Screenshot by author.
43. Yvonne Rainer (right) and Chris Giarmo in *Antigonick*. Photo: Lucy Taylor.
44. Anne Carson. Photo: Jeff Brown. Courtesy of the photographer.
45. Composite of signs.

46. Road with median strip. Photo: Peter del Tredici.
47. Highway with median strip. Photo: Jakec, CC BY-SA 3.0 https://creativecommons.org/licenses/by-sa/3.0, via Wikimedia Commons.
48. Photo: Annie-B Parson.
49. The church of San Gregorio Maggiore in Spoleto, Italy. Photo: Annie-B Parson.
50. Chris Giarmo (left), David Byrne (center), Simi Stone, in *American Utopia*. Photo: Annie-B Parson.
51. Daniel Dod family tree. Source unknown.
52. Drawing: Annie-B Parson.
53. *American Utopia*. Photo: Abigail Lester.
54. Photo: Annie-B Parson.
55. Keith Sabado (left) and Meg Harper in rehearsal for *The Road Awaits Us*. Photo: Annie-B Parson.
56. Keith Sabado (left) and Meg Harper in rehearsal for *The Road Awaits Us*. Photo: Annie-B Parson.
57. Composite of social distancing signs.
58. Mask with Hilma af Klint, *The Ten Largest, No. 2*. Painting. Photo: Annie-B Parson.
59. Open social dance position. Anne Schley Duggan, Jeannette Schlottmann, and Abbie Rutledge, *Folk Dances of European Countries*. A.S. Barnes and Co., 1948, 137.
60. Zoom dance. Photo: Katie Rose McLaughlin/Designated Movement Company's "Line Dance Club."
61. TikTok dance. Screenshot of Google search.
62. Letter of Anton Chekhov (detail). Screenshot.
63. Pot possibly depicting play by Euripides, c. 330s. Oliver Taplin, *Pots and Plays*. J. Paul Getty Museum, 2007, 184.
64. Trisha Brown dancing *Water Motor* in her studio. Copyright ©1978 Babette Mangolte, all rights of reproduction reserved.
65. Parking demonstration. Screenshot.
66. Parking meter. Screenshot.

Permissions (in order of appearance in the book)

Quotation by Fernando Pessoa used with permission from the translator, Richard Zenith.

Shalmaneser III greets Marduk-zakir-shumi, Throne Dais of Shalmaneser

Works Referenced

Anghelaki-Rooke, Katerina. *The Scattered Papers of Penelope*. Graywolf Press, 2009.

Auerbach, Eric. *Mimesis*. Princeton University Press, 1953.

Carson, Anne. *Antigonick (Sophokles)*. New Directions, 2012.

Carson, Anne. *Glass, Irony and God*. New Directions, 1995.

Carson, Anne. *Grief Lessons Four Plays Euripides*. The New York Review of Books, 2006.

Carson, Anne. *Nox*. New Directions, 2018.

Chekhov, Anton. *A Life in Letters*. Penguin Books, 2004.

Christiansen, Inger. *The Condition of Secrecy*. New Directions, 2018.

Dunn, Douglas. Q&A at New York Live Arts, 2007.

Eliot, George. *Middlemarch*. Oxford University Press, 2019.

Homer. *The Odyssey*. Translated by Robert Fagles. Penguin Books, 2006. Original publication 8th–7th century BCE.

Homer. *The Odyssey*. Translated by Emily Wilson. Norton, 2018.

Ibsen, Henrik. *Peer Gynt*. University of Minnesota Press, 1983.

Johnston, Jill. *Marmalade Me*. Wesleyan University Press, 1971.

Kundera, Milan. *The Art of the Novel*. Grove Press, 1988.

Melville, Herman. *Bartleby, The Scrivener: A Story of Wall-Street*. Wilder Publications, 2011. Original publication 1853.

Mendelsohn, Daniel. *Three Rings*. University of Virginia Press, 2020.

Pepys, Samuel. *The Diary of Samuel Pepys*. G. Bell and Sons, 1952.

Pessoa, Fernando. *The Book of Disquiet*. New Directions, 2017.

Riley, James Whitcomb. *The Orphant Annie Book*. Bobbs-Merrill, 1908.

"Robert Rauschenberg – Erased De Kooning." Video interview.

Terms of Endearment. Directed by James L. Brooks, 1983.

Wade, David. *Symmetry The Ordering Principle*. Bloomsbury, 2006.

Plate 10

Gavotte de Pont-Aven